T0150588

THE WATSON GORDON
LECTURE 2008

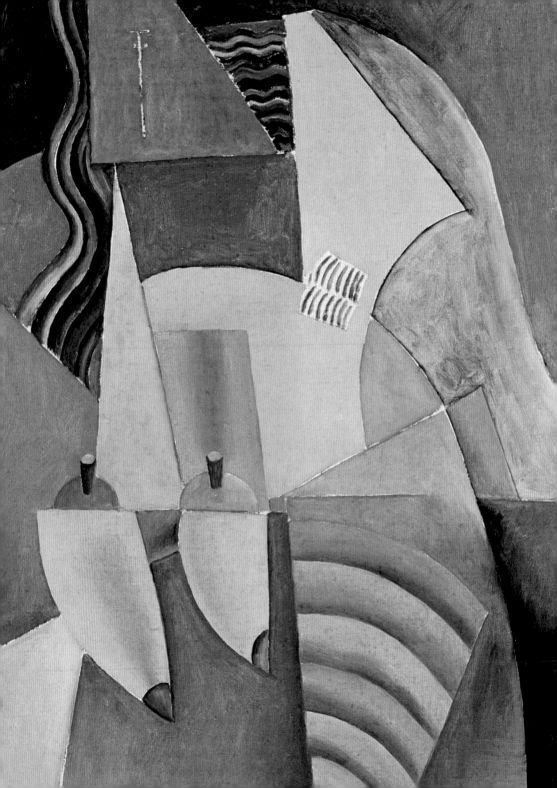

THE WATSON GORDON
LECTURE 2008

Picasso's 'Toys for Adults': Cubism as Surrealism

NEIL COX

NATIONAL GALLERIES OF SCOTLAND

in association with
THE UNIVERSITY OF EDINBURGH
and
VARIE

Published by the Trustees
of the National Galleries of Scotland, Edinburgh
in association with The University of Edinburgh & VARIE
© The author and the Trustees of the National Galleries of Scotland 2009
ISBN 978 1 906270 26 1

Frontispiece: Pablo Picasso (1881–1973)
Detail from *Woman in a Chemise Sitting in an Armchair*, fig.13

Designed and typeset in Adobe Arno by Dalrymple
Printed and bound on Arctic Matt 150gsm
by OZGraf SA, Poland

National Galleries of Scotland is a charity
registered in Scotland (No.SC003728)

FOREWORD

The publication of this series of lectures has roots deep in the cultural history of Scotland's capital. The Watson Gordon Chair of Fine Art at the University of Edinburgh was approved in October 1872, when the University Court accepted the offer of Henry Watson and his sister Frances to endow a chair in memory of their brother Sir John Watson Gordon (1788–1864). Sir John, Edinburgh's most successful portrait painter in the decades following Sir Henry Raeburn's death, had a European reputation, and had also been President of the Royal Scottish Academy. Funds became available on Henry Watson's death in 1879, and the first incumbent, Gerard Baldwin Brown, took up his post the following year. Thus, as one of his successors, Giles Robertson, explained in his inaugural lecture of 1972, the Watson Gordon Professorship can 'fairly claim to be the senior full-time chair in the field of Fine Art in Britain'.

The annual Watson Gordon Lecture was established in 2006, following the 125th anniversary of the chair. We are most grateful for the generous and enlightened support of Robert Robertson and the R. & S.B. Clark Charitable Trust (E.C. Robertson Fund) for this series which demonstrates the fruitful collaboration between the University of Edinburgh and the National Galleries of Scotland.

The third Watson Gordon Lecture was given by Neil Cox of the University of Essex on 20 November 2008. One of Britain's leading scholars of Cubism and Surrealism, Professor Cox is a particular authority on Picasso, approaching the Spaniard's work from intriguing angles, as in *A Picasso Bestiary* and an essay in the exhibition catalogue *Picasso: Challenging the Past*. By concentrating on a single work in his lecture, he vividly demonstrates how scrupulous focus can open out challenging perspectives in the work of a great master.

RICHARD THOMSON
Watson Gordon Professor of Fine Art,
University of Edinburgh

JOHN LEIGHTON
Director-General,
National Galleries of Scotland

FOR DENA

ACKNOWLEDGEMENTS

I should like to thank Professor Richard Thomson for the kind invitation to give the 2008 Watson Gordon Lecture and for his wonderful hospitality. I am also most grateful to the staff of the Scottish National Gallery of Modern Art who were generous with their advice and assistance: Patrick Elliott and Lauren Rigby of the Curatorial Department; Ann Simpson and Kerry Watson in the Archive and Library; Janis Adams, Christine Thompson and Olivia Sheppard in the Publishing Department, and Shona Corner in the Picture Library. With Lauren Rigby I was able to study Picasso's *Head* in its frame when it was hanging in storage, and with Graeme Gollan, Senior Paper Conservator, I had the memorable experience of seeing the work out of its frame. My colleague Dawn Ades, who always found a crucial reference for me when I had drawn a blank, was kind enough to let me borrow her original edition of *Le Surréalisme et la peinture*. Other colleagues, in particular Peter Vergo and Wolfgang Brückle, made incisive comments on an earlier version of the talk.

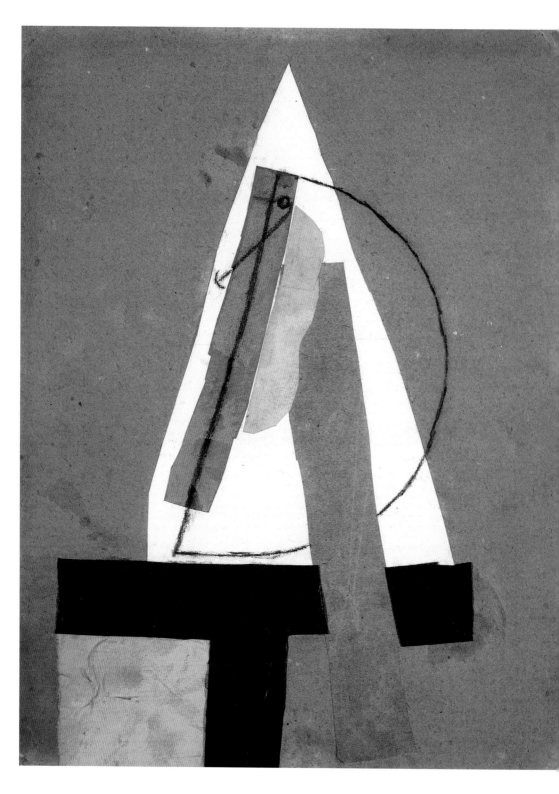

PICASSO'S 'TOYS FOR ADULTS': CUBISM AS SURREALISM

'WHEN WE WERE CHILDREN...'

I am going to speak this evening of a single object now in the collection of the Scottish National Gallery of Modern Art in Edinburgh (fig.1). It is a work on cardboard, made with papers of several colours that have been pasted on to it, and a few black chalk lines. It is called *Head*, and it is a work by Pablo Picasso (1881–1973) usually dated to the spring of 1913. It is a grubby little thing, forty-five by thirty-three centimetres, consisting at very first glance of a white triangle, a blue rectangle, alongside that a smaller greyish undulating 'B' shape, the whole sitting on a black 'T' shape. There is a dirty, yellowed square to the bottom left underneath one arm of the 'T' (fig.2). Much more difficult to discern – it depends on the conditions in which the object is seen – is another strip of paper that passes over the 'T' and up into the core of the white triangle (fig.3). Or perhaps it passes downward... Words here are prejudicial to the act of looking, for metaphors of up and down and crossing over come easily in even a supposedly basic description.

There's one more thing, of course: the black chalk lines in the form of a broken 'D', a tiny circle at the top of the blue rectangle, and a diagonal line (that is to say *more* diagonal than the spine of the 'D') that resembles a schematic anchor, the hand of a clock or, perhaps, the needle of a compass (figs.4, 5).[1] The 'head' sits in a large visual field of exposed ground, the cardboard. There is no hint of atmosphere, or even of air, other than that created by its strange configuration. By now I have probably identified everything that there is to be seen in this thing – every one of its elements.

I just said that some things depend on the conditions of viewing. The details that I have been showing give a 'back of house' glimpse of the surface, working

FIG.1 | PABLO PICASSO (1881–1973)
Head, 1913
Papiers collés with black chalk, white gouache on cardboard 43.5 × 33cm
Scottish National Gallery of Modern Art, Edinburgh. Purchased with assistance from the Heritage Lottery Fund and The Art Fund 1995

FIG.2
Detail from *Head*

photographs, when the cardboard has been removed from the gilt frame in which it has been at home since – as can be seen from this London exhibition installation photograph – at least the mid-1930s (fig.6). Its tatty edges are exposed, as is the end of that strip of paper that runs from the triangle, through the 'T', down towards the lower edge (fig.7). The frame hides such means of the work, sublimates its mundane existence a little.

Writing about *Head* in 1939, the then director of the Museum of Modern Art in New York, described it as '[o]ne of the most arbitrary and abstract of Picasso's cubist compositions in its remoteness from the object indicated by the title'.[2] In saying this, Alfred Barr drew attention to the way the representation exists on the fringes of resemblance, and how strongly but awkwardly the title anchors the representation to a certain kind of reading. And, of course, he uses the term 'cubist' to describe it.

[10]

FIG.3
Detail from *Head*

The source of that 'remote' title is unknown, though we do know that when the work was first illustrated as early as 1922 in a book by critic Maurice Raynal, it was already called *Head* and described as a 'drawing with papiers collés' (pasted paper), dated erroneously to 1914 (fig.8).[3] In that illustration we can discern a stronger contrast between that central stripe and the colour of the background cardboard; evidence perhaps – and we can't be certain of this because of the analogue effect of black and white photography vis-à-vis colour – of the mutation of the colours of the paper elements over ninety-odd years.[4] Whatever the colour, this thing was to be seen as a 'head'. Much later on, in the 1960s, Pierre Daix discussed the work with Picasso. The dialogue went something like this:

Picasso: 'That's a head.'
Daix: 'That thing with the triangle?'
Picasso: 'But it's a head, it's a head.'[5]

[11]

FIG.4
Detail from *Head*

So our *papier collé* may always have been a head in Picasso's head, notwith-standing the degree of difference it presents when compared with the tradition of representations of heads in European art. According to an early patron, the American Leo Stein, Picasso mused upon this epochal shift in terms that seem to fit with our strange triangular being: 'a head... was a matter of eyes, nose, mouth, which could be distributed in any way you liked – the head remained a head'.[6]

'THE TOYS OF OUR WHOLE LIFE SPREAD OUT BEFORE US...'

Picasso made this *Head* in Céret, in the foothills of the Pyrenees just inside the French border, in the spring of 1913. It is one of a large group of works – but that is only to say that it is part of a series of works that use similar configurations whose limits are for us to choose. From one point of view this series might only consist of twenty or thirty things; from another it extends over a very long period in

FIG.5
Detail from *Head*

Picasso's work from late 1912 through to, well, let's say 1914. In either case the series includes not only *papiers collés*, but drawings, paintings and constructions. Looking across the smaller range of work tells us that Picasso recycled his triangle, black strips, clock hands and semicircle in various ways – thoughts of heads had been circulating for some time, and suffering sea changes at each new manifestation.[7]

Even before Picasso left for Céret sometime around mid-March 1913, he may have begun *this* head (fig.9), using dressmaking pins instead of glue, which shares with ours many elements.[8] Once in Céret Picasso played with this way of making heads; a white pasted slab makes a face, pinned again, perhaps in a half-hearted sign of a wrinkle, while elaborate charcoal drawing gives clues to some of the more abstract forms in the Edinburgh *Head* (fig.10). Those clock hands, or lines like schematic anchors, rotate around the face to make, among other features, a moustache, a nose, the indent beneath the lower lip. Two myopic dots stand for eyes.

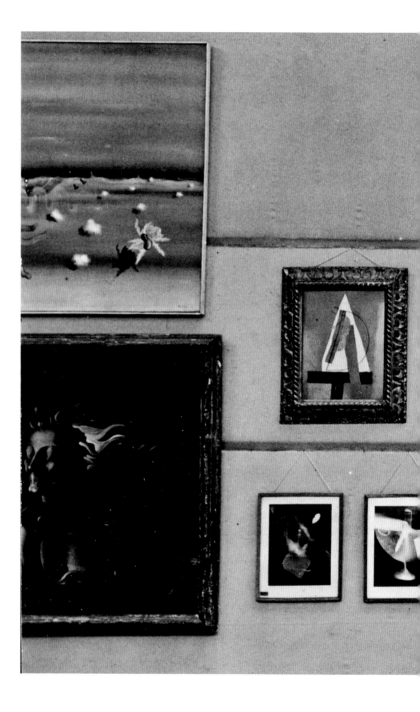

FIG.6
International Surrealist
Exhibition, New Burlington
Galleries, London, 1936.
Roland Penrose Archive
Scottish National Gallery of
Modern Art Archive,
Edinburgh

FIG.7
Detail from *Head*

The 'D' shape to the right is shallow this time – but it still provides for the idea of the form of the head, its roundness. Meanwhile, two further planes notionally parallel to the paper ground jostle a little; off their outer edges hang wavy ears. A hat appears, now as dark, now as light, in the upper reaches of the picture.

Yet neither of these two works offers any benchmark for the triangular structure in our *papier collé*, nor that black 'T' shape. One of the many sketchbooks preserved by Picasso and now held in the Musée Picasso in Paris gives a better back-story. Sketchbook 17 has seventy-eight pages of drawings completed in Céret during the spring and summer of 1913. The recto of Sheet 51 appears to be a study for the Edinburgh *Head*, where we see Picasso with faint pencil lines pondering the role of that strip on the right that would eventually run down the length of the figure (fig.11). Triangular structures are common in the sketchbook. Among the inventions that parade across the pages are a large number of works featuring black elements and triangular forms. The identities of these configurations vacillate: one minute there is a guitar, the next a musician, the next a still life.

The promiscuous inter-breeding of heads and guitars in this sketchbook was

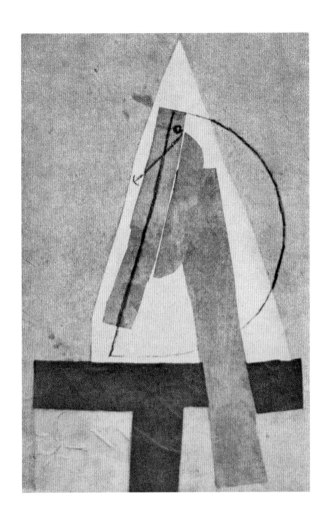

FIG.8 | MAURICE RAYNAL
Picasso, Paris, 1922, pl.XXV
Roland Penrose Archive
Scottish National Gallery of Modern Art Archive, Edinburgh

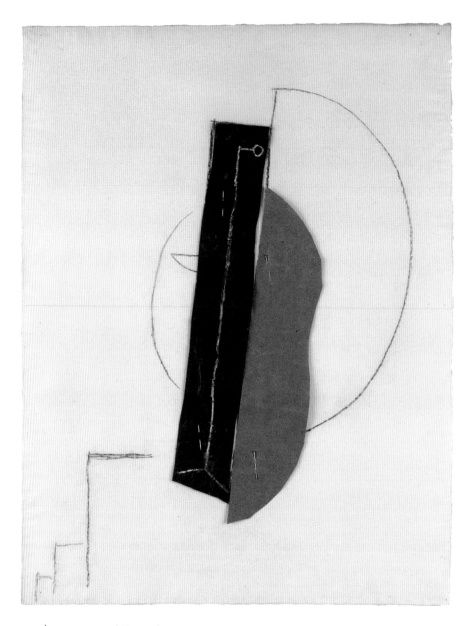

FIG.9 | PABLO PICASSO (1881–1973)
Head, early 1913
Coloured paper, pins, crayon and charcoal on Ingres paper 61.7 × 46.8cm
Musée Picasso, Paris

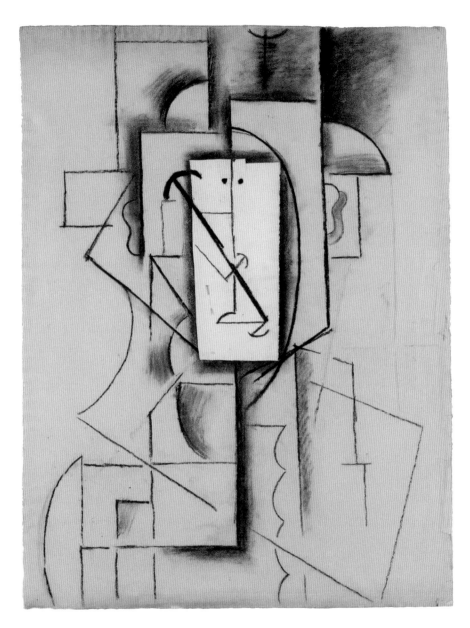

FIG.10 │ PABLO PICASSO (1881–1973)
Harlequin's Head, 1913
Pasted paper, pin, charcoal on Ingres paper 62.7 × 47cm
Musée Picasso, Paris

played out in paintings and *papiers collés*. Perhaps the closest comparison is *Guitar*, now in the collection of the Musée Picasso, one of those hundreds of works that Picasso kept throughout his life and also an exceptional foray in the direction of abstraction (fig.12). I say 'closest' even though the elements here are different; the drawn lines are absent, and the guitar lacks the anchored weight of the head. Nevertheless, in its simplicity, basic configuration and, of course, abstractness, this object is the true partner of our *Head*. What those chalk lines do in the Edinburgh work is to make the crudest suggestion of features (an eye, a nose, and then by implication an ear, hair) that throw the materiality of the abstract forms back into representational space.[9]

So much for what can be gleaned from a close visual examination of our *Head*, and from a glance back to its context in Picasso's work during 1913. How then, since 1913, has this work been interpreted? How has it been understood? Recent accounts of this work range from strictly biographical ones to narrative treatments underpinned by an austere and precise analysis of formal development. For the biographer John Richardson the work belongs to a series clothed in the black of mourning, a response to the recent death of Picasso's father on 3 May, 1913.[10] Pepe Karmel, on the other hand, reads the work in the context of Picasso's exploration of the theme of the transformations between figure and object, content and form, painting and sculpture. He also makes telling points regarding Picasso's reinventions in hundreds of drawings of earlier favourite cubist representations (for example, guitar players), as if they could become constructed sculptures, which of course, in a sense, some of them did.[11]

Barr's early treatment of *Head* as an instance of Cubism goes to the heart of the matter, for I want to suggest that the notion of Cubism, notwithstanding the weight of authority that supports it in our histories of Picasso's art, has only limited value for a reading of this work, and that instead we should regard it as *surrealist*. Putting it that way might seem like a simple matter of classifications and categories, an argument over which of the 'isms' on the chart of modern art is the best box in which to put our picture. Of course, the isms of modern art have their place in our management of the heritage and the construction of the meta-history to which they belong, the history of the biggest ism: Modernism.

FIG.11 | PABLO PICASSO (1881–1973)
Sketchbook 17, Sheet 51R
Musée Picasso, Paris

Moreover they are not arbitrary; Surrealism was an identifiable movement with a membership, its own publications, exhibitions, and manifestos. Cubism was a term originating around late 1908 that became the name for a new kind of art. The word 'Cubism' circulated in an elaborate system of texts in newspapers, exhibition catalogue prefaces and manifestos written by artists, most aiming to articulate what Cubism really was.[12] Yet, and this was even the case during those years before the First World War, many writers acknowledged that the currency of the term 'Cubism' was debased almost as soon as it appeared.[13] Worse still, in the great years of what we conventionally call his Cubism, Picasso made virtually no public statements of his intentions in any form. Rather, he declared himself in a letter of April 1913, just around the time when he made *Head*, to be 'quite disappointed with all this chatter'.[14]

And then again, to discuss Picasso and Surrealism is not new. There are many excellent treatments of the motivations on both sides for the forging of the relationship between Picasso and various aspects of Surrealism.[15] Clever things have been said too of the impact of Surrealism on Picasso's art, and recently on the ways in which it was caught up in, and can be read in terms of, critical and theoretical debates between official Surrealism and the so-called 'dissident' Surrealism of Georges Bataille and others.[16] I wish to come at the matter from another direction: it is my aim to explore a *particular* surrealist text for its surprising and, I think, rather profound reading of Picasso's art not only during the heyday of Surrealism, but also back in the so-called cubist years. In general terms I want to emphasise a fact that applies to all historical works of art: that how we see them is a negotiation between their presence, their persistence as physical objects that can be subjected to close visual scrutiny, and the structures of interpretation that have been developed subsequently in order to make sense of them. That negotiation is never simple, since how we look, when we look at the work of art, is always structured or informed by our notions about it, notions that result from the history of previous interpretative language. So by shifting attention away from the notion of Cubism in the direction of Surrealism, I want to disturb the terms of our looking and our thinking, to bring to the fore the construct that is our habitual glance at, for example, Picasso's Edinburgh *Head*.

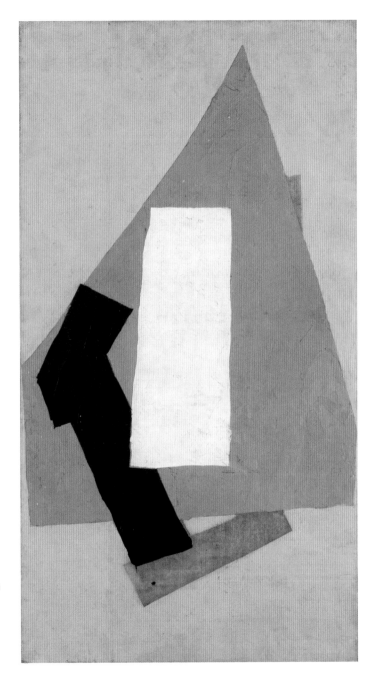

FIG.12 | PABLO PICASSO (1881–1973)
Guitar, Spring 1913
Oil on canvas pasted onto wood 87 × 47.5cm
Musée Picasso, Paris

The point, in part, is to estrange our *Head*, and in so doing to return to it, for reasons that I have yet to make clear, what could be called its sardonic character. Without yet defending the use of such a word, I intend it to resonate in the gap between the crude figuration of our object and the very idea of Cubism.

‘THE DRAMA WHOSE ONLY THEATRE IS THE MIND…’

So let me begin that argument with the two parts of my title: ‘Toys for Adults’ and ‘Cubism as Surrealism’. The first part is a truncated phrase from a text by the leader of the surrealist movement, André Breton, the text that I want to focus on in the rest of my lecture.[17] In fact, fragments of that text have been appearing mysteriously as section titles from the beginning of my talk.

The second part, ‘Cubism as Surrealism’ was, I thought at first, my own invention, but it turns out that Alfred Barr, the museum director who described our *Head* as cubist in 1939, got there long before me. He used the phrase as the title for a section of his book *Picasso: Fifty Years of His Art* of 1946, a section that includes an illustration of our *Head*, described in entirely new terms:

> *The collage… is greatly admired by the surrealists and is in fact owned by a surrealist artist. It… is titled* Head, *but as a head it is so fantastically far-fetched that it easily meets the surrealist aesthetic of the marvellous…*[18]

So my shift in reading, from Cubism to Surrealism, is itself already inscribed in the historiography of the Edinburgh *Head*. In Barr’s short statement it remains, though, an un-deciphered inscription, even if Barr does suggest that something about our *Head* makes it peculiarly suited to what he calls a ‘surrealist aesthetic’.

Turning then to Breton’s words, their context is a polemic that is also a manifesto; an intervention in an on-going debate among his fellow travellers of Surrealism regarding the very viability of the idea of surrealist visual art. The painter André Masson claimed that he discussed the issue of what would be the best title for the text with Breton.[19] They agreed upon ‘Surrealism and Painting’, a book which began life during 1925 as a series of articles in the first journal of Surrealism, *La Révolution Surréaliste*. The ‘and’ in the title was a way of maintaining the distinction between these two apparently distant entities, an avant-garde

movement on the one hand, and a visual medium, a set of particular historical practices and achievements, on the other.[20]

So much for the background; here is the paragraph from Breton's essay, the one from which our phrase comes:

> *When we were children we had toys that would make us weep with pity and anger today. One day, perhaps, we shall see the toys of our whole life spread before us like those of our childhood. It was Picasso who put this idea into my mind (the* Woman with a Chemise *of 1914, and the still-life in which the inscription 'VIVE LA' stands out boldly against a white vase above two crossed flags). I never received this impression so strongly as on the occasion of the ballet* Mercure, *a few years ago. We grow up until a certain age, it seems, and our playthings grow up with us. Playing a part in the drama whose only theatre is the mind. Picasso, creator of tragic toys for adults, has obliged man to grow up and, sometimes under the guise of exasperating him, has put an end to his puerile fidgeting.[21]*

You will no doubt have noticed that the title of my lecture withholds a crucial adjective from view: 'tragic'. Ever since I first read this paragraph some twenty-two years ago, Breton's words have stuck in my mind not for their clarity but for their opacity. What does it *mean* to describe Picasso as a *moralising* toy-maker? How could this mental drama confront us in such a way as to drag us, with a rude shock, to our maturity? And how do the three works by Picasso mentioned by Breton relate to the story of the supposedly 'tragic' change in the significance of childhood toys from the perspective of adulthood?

The painting Breton calls *Woman with a Chemise* (which is possibly from late 1913 rather than 1914) (fig.13), together with a still life that he identifies by a phrase painted on it, are already surprising, apparently different, figurations of the ostensible theme of the toy.[22] Indeed, Breton is a little way into his discussion of Picasso, the very first artist mentioned by name in *Surrealism and Painting*, by the time he refers to *particular* paintings, but when he does so it is not immediately to *these* works but to what he regards as the founding moment or turning point in Picasso's career, the invention of Cubism.

> *One day people will discuss passionately the question of what sudden impulse spurred Picasso towards the end of 1909. Where was he then? How did he*

[25]

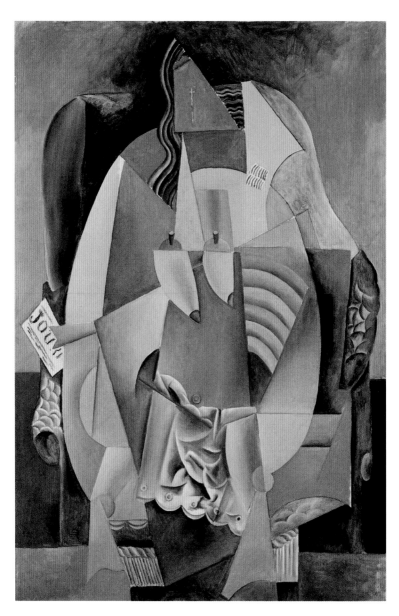

FIG.13 | PABLO PICASSO (1881–1973)
Woman in a Chemise Sitting in an Armchair, 1913–14
Oil on canvas 148 × 99cm
Private Collection

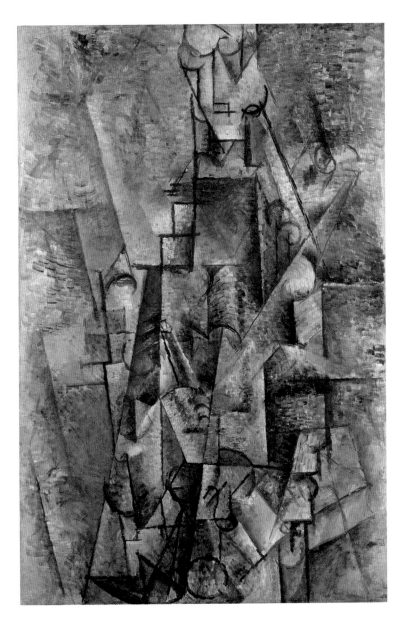

FIG.14 | PABLO PICASSO (1881–1973)
Man with a Clarinet, 1911–12
Oil on canvas 106 × 69cm
Museo Thyssen-Bornemisza, Madrid

live? That ridiculous word 'cubism' can never conceal from me the enormous
significance of that sudden flash of inspiration which I am convinced occurred,
in terms of his artistic production, sometime between Factory, Horta del Ebro
and Portrait of M. Kahnweiler.[23]

Notwithstanding his own scepticism over the term 'Cubism', a word whose
significance for recent art had been even more contested in avant-garde circles
since the middle of the war, Breton says little of the works that he regards as
constitutive of Picasso's 'revolutionary' achievement.[24] He then mentions the
1911–12 painting *Man with a Clarinet* (fig.14) only to pass wistfully over it:

> *We leave behind us the great grey beige 'scaffoldings' of 1912, the most perfect*
> *example of which is undoubtedly the fabulously elegant* Man with a Clarinet,
> *whose 'parallel' existence must remain a subject for endless meditation.*[25]

Breton did indeed regard that period between *Horta* and the Kahnweiler portrait
as a great moment in the rise of the modern, truly seductive and mysterious, and
his attachment to works of 1911–12 like *Man with a Clarinet* was perhaps equally if
not more profound, based upon a belief in their effectiveness as entrées to a realm
of fantasy. The parallel existence he attributes to that work is just that of Alice
through the looking glass, as if we see through the surface of Picasso's painting to
another kind of reality. What he permits himself to say of any of these works, so
well chosen, is thus hardly direct criticism or analysis; rather, his principle object
is the true focus for the lyric poet – his own affective life in the face of art.[26] And
with Breton's lyric criticism comes a strong sense of an ethical imperative.

What we leave these works behind in favour of are those 'tragic toys for adults',
works from 1913–14, and much more bizarrely, the décor for a short ballet of 1924
(fig.15). This ballet forms the bridge in Breton's text between pre-war Cubism and
Picasso's various manners of the early 1920s. *Mercure*, with music by Erik Satie, was
the last of Picasso's important engagements with the ballet, and was promoted by
an aristocrat and supported by the haute bourgeoisie of Paris. The opening night
of this ten-minute affair was also attended by members of the nascent surrealist
group, including Breton and Louis Aragon. They shouted 'Bravo Picasso, down
with Satie', jumped onto the stage and caused a rumpus.[27] One way of under-
standing this is as part of a strategy of appropriation, where the surrealising of

[28]

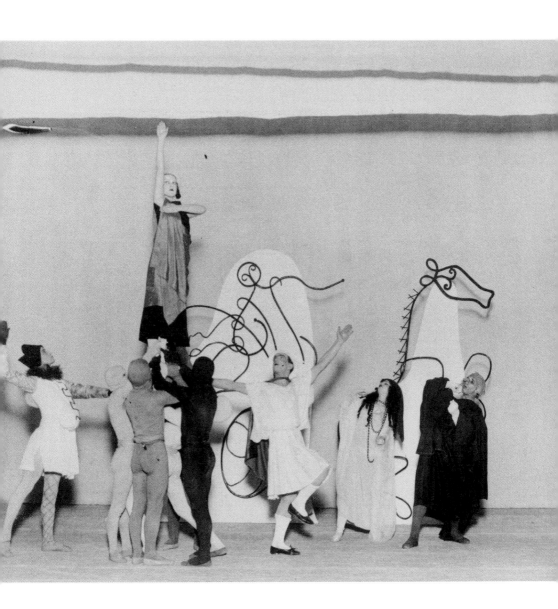

FIG.15 | BACCHANAL SCENE
Mercure with set and costume designs by Picasso, 1924
Musée Picasso, Paris

Cubism and of even Picasso's most apparently bourgeois activities is designed to draw him, as a key cultural asset, into the orbit of the movement, an approach brilliantly developed by Elizabeth Cowling in a well-known essay of 1985.[28] What is certainly true is that although Breton is determined to give Picasso the priority in his examination of the nexus of 'Surrealism' and 'Painting', Picasso's recent art, including his forays into neo-classicism and his ballet designs, presented Breton with special difficulties. What Breton seeks to achieve in his paragraph on toys is to link the radicalism of pre-war Cubism to neo-classicism and to the ballet designs, to find a language to capture them all. Crucially, the pre-war Cubism that Breton cites in this specific context is that of the last few years before the European conflagration: 1913–14. Somehow the discourse of tragic toys can only work, it would seem, for works near the brink of what Breton knew, with hindsight, would be the onset of war. From where, then, does this discourse of toys spring? And how, again, can such 'toys' as *Woman in a Chemise*, or our Edinburgh Head be seen as 'tragic'?

One way of tracing the origin of these ideas is to examine the precedents for Breton's text. Several of the works mentioned by him had been illustrated before in important contexts. The *Horta* painting and *Man with a Clarinet* appeared before the Great War in the pages of Guillaume Apollinaire's *The Cubist Painters: Aesthetic Meditations* of 1913 as the first and third illustrations.[29] As a young man Breton had once discovered Picasso's constructions in the astonishing issue of *Les Soirées de Paris* edited by Apollinaire in November 1913. The publication of these extraordinary works cost the journal dearly: many of its readers cancelled their subscriptions in protest.

Thus, if we were seeking a model for Breton's critical approach, we might be tempted to look in Apollinaire's own writings. Breton's relationship to Apollinaire and to his legacy was not straightforward, however. For sure, Apollinaire's *The Cubist Painters*, like *Surrealism and Painting*, began with a general discussion of modern painting before turning to its first subject, Picasso. The doctrine of 'surprise' in art that Apollinaire promoted there and in later texts also interested Breton; it can be seen as an underpinning of the latter's promotion of the aesthetic of the 'marvellous' mentioned by Barr and, later, of the 'chance encounter'.

Apollinaire's publication notes for his play of June 1917, *The Breasts of Tiresias*, famously proclaimed it a 'surrealist drama', and he had used the term publicly the month before in his programme notes for Jean Cocteau's ballet *Parade* with décor by Picasso. Apollinaire thus coined the word that would provide the basis for Breton's mature activity.[30] Yet at the same time Apollinaire actually had a rather poor eye as critic, and more importantly his position towards cultural values at the end of his life was, from Breton's point of view, politically suspicious. The conflicted nature of Breton's relationship to Apollinaire is clear if one reads first his adulatory portrait of the poet of late 1918, and then the lecture 'Characteristics of the Modern Evolution' of 1922, in which Breton more or less condemns Apollinaire's 'ridiculous attitude near the end of the war' and labels him, disdainfully, a curiosity.[31] The line in the sand between Apollinaire's Surrealism and Breton's use of the term is also in this way part of a larger argument taking in the political positions adopted by cultural figures in response to the First World War. And perhaps, at a certain level, the war functions as the currency of Breton's sense of the tragic in his discussion of Picasso's trajectory from 1913 to 1923.

There is another register of that word 'tragic' in play, I think. John Golding once suggested a point of reference for Breton's *Surrealism and Painting* in Charles Baudelaire's famous 'Salon of 1846', with Picasso being substituted for Eugène Delacroix as the hero artist.[32] Baudelaire, the quintessential 'lyric poet in the era of high capitalism', was also an obsessive moralist (though the morality in question incorporated an excessive idealism alongside an agonised eroticism: Baudelaire was 'surrealist in his morality', according to Breton's 'First Manifesto of Surrealism'). That moralising tone carries straight through into Breton's weighing of souls in *Surrealism and Painting*. 'I am very lenient,' says Breton, but the constancy of the commitment of artists to the quest for parallel existences is always being judged, and any signs of wavering by such artists is roundly condemned by him.

I believe that another Baudelaire text might be important for the treatment of Picasso in the passage lamenting the tragedy of childhood toys: Baudelaire's dazzling and curious 'A Philosophy of Toys' first published in 1853, and whose French title is *Morale du joujou*, perhaps better translated as 'The Moral Philosophy

of Toys'.[33] Baudelaire celebrates the capacity of children 'for abstraction and their high imaginative power'.[34] But typically Baudelaire's exploration of this world is shot through with the melancholy of disenchantment. Sometimes high art fails in comparison to the childhood toy:

> *The toy is the child's earliest initiation to art, or rather for him it is the first concrete example of art, and when mature age comes, the perfected examples will not give his mind the same feelings of warmth, nor the same enthusiasms, nor the same sense of conviction.*[35]

Sometimes the child who seeks to dissect the toy and to grasp what makes it tick is doomed to disappointment:

> *The child twists and turns his toy, scratches it, shakes it, bumps it against the walls, throws it on the ground… at last he opens it up, he is the stronger. But* where is the soul? *This is the beginning of melancholy and gloom.*[36]

It is, I believe, in this spirit that Breton refers in the same breath to Picasso's late Cubism and his ballet design. The 'tragic toys for adults' are those toys that infuriate in their subversive refusal to be the magical things of childhood. Yet how can we interpret this in terms of Picasso's art? 'Childhood' could be an allegory for the naive belief in reality that belonged, according to Breton, to the bourgeois world view embodied in nineteenth-century science and literature. This is just the narrative that Breton sets out as the background to Surrealism's project of the unification of dreaming and waking states in the first 'Manifesto of Surrealism'.[37]

On this reading, Picasso's *Woman in a Chemise* or the ballet *Mercure* defy the expectations of the bourgeois audience that seeks the assurance of a fixed and factual reality. The monstrous eroticism of the *Woman in a Chemise*, for example, provokes an irruption of desire in the forms of those tacked on breasts and shuffling fleshy folds, even while she sits in her bourgeois armchair with its fringed borders and overstuffed arms, clutching a daily newspaper.[38] Her 'marvellous' appearance is, in the terms of another Bretonian coinage, given to us in 'convulsive beauty'. The certainties of bourgeois everyday life and bourgeois morality are overturned by the manifestation of ecstatic or violent desires in reality itself. This creature-woman, another of Picasso's beings with triangular heads, could thus be seen (ironically) as the deflowering agent of an 'innocent' bourgeois relationship

to reality, a reality that now must make the bourgeois weep with anger both over its demise and in pity at his own naivety. Like Baudelaire's child who dismantles his toy in order to find its soul, the bourgeois has looked inside his own fantasy and found not reality but disturbed dreams, violent behaviour and uncontrollable desires. He is awoken, so Breton thinks, by Picasso's designs for *Mercure* to the melancholy of a post-war world. It is in this new world, where Breton thinks all agree on the need to revise the notion of reality, that the 'purely internal model' of the work of art must now act as our guide.[39]

But it is also possible to see a different kind of troubling narrative in the notion of those tragic toys, one that relates to Breton's own narration of Picasso's art, where the childhood that is being lost to experience is not bourgeois realism but the short period when Modernism's dream of another kind of reality had all the 'high imaginative power' of a universe of toys. It is the wonderland of the invention of Cubism; the moment of Picasso's art before the advent of war wrought such changes in it, and the tragic conversion of that moment into the ironies and masquerades of post-war ballet designs and slightly ridiculous neo-classical bathers.[40] With this latter reading there is an ambiguity however: when exactly was that world of toys at its most bewitching? In which precise years or works, in Breton's narrative, did Picasso's pre-war art conjure up childhood wonder, a fantastical space of play, and when did that universe crumble, and the toys suddenly seem pathetic, infantile, or tragic?

'… HAS OBLIGED MAN TO GROW UP …'

You may be wondering what role the Edinburgh *Head* plays in Breton's argument, since it is *not* mentioned by him. It does, in fact, feature in the book version of the original essays. It is prominent in the compelling visual accompaniment that follows the text, being only the second illustration in the unpaginated sequence.[41] I want to claim that, in Breton's thinking, *Head* stood for just that moment in his text when the fantasy of childhood turns sour, when toys become tragic, and when adulthood, with its Baudelairean melancholy and gloom, is inaugurated. But the force of the work is in its double nature – it enacts, I mean to say, *both* the most bewitching toy-world *and* the moment of the demise of ludic magic.

[33]

Breton had a special relationship to the Edinburgh work. In one of the bitter ironies of the art market in the aftermath of the Great War, Breton acquired *Head* in the Kahnweiler sale of 7–8 May 1923. As a German, the great cubist dealer Daniel-Henry Kahnweiler's stock was subject to sequestration by the French state in August 1914.[42] Worse still, Kahnweiler lost all potential buyers for the works on his books at the outbreak of war – most of the key collectors of Cubism were in Germany, Switzerland and Russia. Kahnweiler owed Picasso around 20,000 francs by the end of 1914, money that, after a futile rush to shut down his business and save his reputation, he had no way of paying. Picasso, always quick to protect his financial interests, cut himself off from his friend and supporter Kahnweiler and commenced legal proceedings to recover the debt. Picasso persisted with his claim right through the war. Kahnweiler wrote to Picasso on friendly terms in February 1920 in order to explain the reasons why he had been unable to pay the 20,000 francs, and in an effort to persuade Picasso that the enforced sale of the stock would do nothing for Picasso's market prices. Picasso was unmoved, and his determination, along with that of other artists, to be paid what he was owed led directly to the four auctions between 1921 and 1923.[43] So, since there was virtually no market for Cubism in France in the early 1920s, Breton got his collage on the cheap, while fellow poets and nascent surrealists Paul Eluard and Robert Desnos also bought pasted paper objects by Picasso and Braque. Thus the championing of Cubism by Surrealism was, in a sense, founded on Kahnweiler's economic misfortune.

The back of the cardboard object tells the story of Breton's luck, and later of his *own* misfortune (fig.16). Among the exhibition labels there are several bearing Breton's name, but in the top right there is a Museum of Modern Art label from 1939, the year of Alfred Barr's great show on forty years of Picasso's art, showing the owner's name as Roland Penrose. For Breton himself was to fall victim to the brute realities of economic life. He invested a good deal of his earnings from his books of poetry, his novels and his polemics, in works of art. But by 1936, when he was invited to attend the opening of the International Surrealist Exhibition in London, he was sufficiently penniless as to need a grant from the Ministry of Education in order to travel, and he stayed with the show's curator, Roland

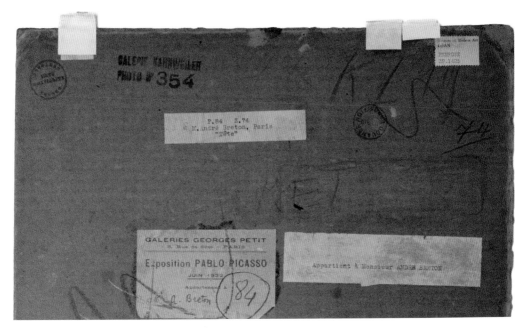

FIG.16
Detail of back of *Head*

Penrose, at his house in London. Breton lent Picasso's *Head* and several other works from his collection to the exhibition.

Breton and his then wife Jacqueline Lamba were photographed together in front of an assemblage of pre-war paintings by Giorgio de Chirico including Breton's own *The Child's Brain*, a recent bone-like *Head* by Picasso, and, of course, the coveted *Woman in a Chemise* (fig.17). During the visit, Penrose realised that Breton might well be inclined to realise some cash through a few sales, and he set about negotiating to buy the Edinburgh *Head* from Breton. Breton wrote to Penrose on 6 July 1936:

> *Thank you again for having dreamt of acquiring this Picasso* papier collé. *I know that your desire to help me dictated this charming offer. But I am madly keen*

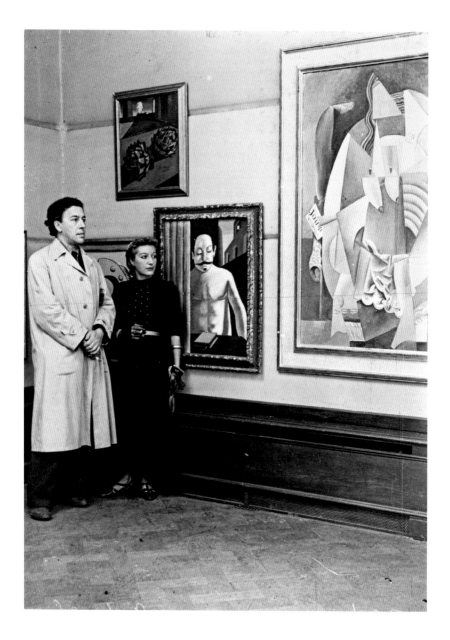

FIG.17
André Breton and Jacqueline Lamba at the International Surrealist Exhibition, New Burlington Galleries, London, 1936. Roland Penrose Archive, Scottish National Gallery of Modern Art Archive, Edinburgh

to keep this little picture that took me years to track down before I was able to contemplate it at leisure. It is also the last Picasso I have, and I fear, that when I no longer have it I will feel poorer still. I know that you will understand the sentiment admirably.[44]

This was followed by another letter written on 20 February 1937, when Picasso's *Head* was at last being sent to Penrose.

I hope that my situation will take a new form and that I shall cease to be so indebted to my friends. They have promised me that the Picasso will be with you a week on Monday. May it long be as moving, as tender and as favourable as it has been to me during these past fifteen years.[45]

'... AN END TO HIS PUERILE FIDGETING.'

When Breton worked on *Surrealism and Painting*, even though he does not directly refer to our *Head* in the text, it is clear that it was ever present in his thoughts, hanging in his apartment as he wrote. Preceded in the illustrations to the book only by another *papier collé* from 1912, it can stand for the inauguration of the disenchanted toy-world that chastens and mocks a lost modernist dream, a once fantastical realm of object-personalities.

At one level we might say that *Head* is a more perfect cubist 'toy' than any we can imagine, with its hilarious one-eyed gaze and strange mechanical nose turning on a conical visage. It mimics too a child's cut outs with their sloppy gluing and eccentric shapes. Yet as a 'toy' it fails to do the job: unlike *Man with a Clarinet* it conjures up no parallel world of Alice. Instead it smirks its way to half-hearted representational certainty with a series of awkward gestures, a strip of paper here, a badly drawn half circle there. At the same time, though, and 'under the guise of exasperating' us, this *Head* is much more sophisticated, or even sophistic, much less the naive vision of the child, than it looks.

In *Man with a Clarinet* the form of the musical instrument is woven into an atmospheric shifting of planes through a claw-like hand, in a fashion that eludes simple description. The presence of the man spreads out into the surrounding space in so many shudders of light and dark. Here, a curling line is a shoulder, there, the circumference of an arm, and there again, the open mouth of the clarinet.

FIG.18
Detail from *Head*

The existence of this man is, as Breton rightly suggested with his lyric criticism, as magical and mysterious as any imaginary world evoked by a fairytale.[46]

Turning once again to our *Head*, and bearing in mind the subtlety with which representation is effected in *Man with a Clarinet*, it is worth looking more closely at a few visual incidents that I passed over quickly at the beginning. Studying the surface again reveals its ill-concealed means (fig.18). We can see that the black chalk D only feigns to pass under the long strip that runs vertically, whereas in fact it stops at one edge and resumes its course at the other thanks to very deliberate drawing. And then we can see that the strip only *pretends* to be pasted over the black T, whereas in fact the black T makes way for it thanks to fairly casual cut-and-paste work (fig.19). Or again, the grey curvy shape to the left of the blue rectangle is not, as it pretends, a single piece of paper; one curve is carefully joined at the top (fig.20). Under the magnifying glass it becomes clear that the top right

FIG.19
Detail from *Head*

edge of the white triangle has been sharpened up with a knife. Meanwhile white gouache has been deployed to solidify the appearance of the triangle, to tidy up its texture, and indeed to soften up the blue rectangle. Truly these are odd gestures of perfectionism in the context of the glue stains that catch raking light, or the dirty fingerprints in the pale yellow square at bottom left. We are deep in the world of Picasso's play; his cutting-and-pasting workbench, his hobbyist tricks. The wheezing and clunking mechanics of the work are gleeful – but the performance is only posing, in an amateurish way, as magic. The work feigns infantile mess and play through consummate adult skill.

We are forced to stop believing, so Breton thinks, in the promise of Cubism, the promise of a parallel universe or a new reality, by these gauche, these tongue-in-cheek efforts at *trompe l'oeil*. The very devices that were once so subtly worked through and that made our toys, this cubist utopian universe of representation so

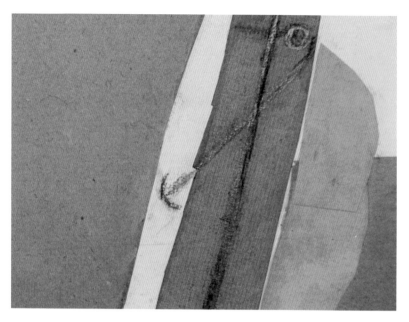

FIG.20
Detail from *Head*

enchanting, are now being deployed and disported like so many tricks in order to quash our puerile love of Modernism's magic, disported in a very beautiful, quirkily naive toy-image. *Head* is at once a magical toy and a tragic one; it hovers in the moment of a lost innocence. Breton finds in this post-cubist Cubism just the kind of vigorous resistance to naive confidence in modern art that Surrealism was designed to promote. He also finds in it, I think, the means to a spiritual exercise, a moral corrective, 'an end to his puerile fidgeting'.

Baudelaire's melancholy, in his 'Moral Philosophy of Toys' was in part based on the notion that we cannot return to our childhood imagination; that we cannot abandon the self-knowledge of adulthood. His poetic criticism is the subjective lament over the moment when the naive becomes sentimental, becomes

self-consciousness – and paradoxically it is in this same moment that the toys of childhood can be seen for what they were: toys. So too for Breton, who sees the beauty of Cubism all the more intensely for having been forced to give up the dream of the new reality that it promised. The Edinburgh *Head* provided the éclat that, for Breton, transformed pre-war Cubism into a post-war Surrealism: it could do so in part because it had languished, unseen, in Kahnweiler's stock room for so long. It sprang into life and found its meaning in a new context: a whirring, spinning, magic toy made of all-too-knowing adult tricks.

BIBLIOGRAPHY

ANTLIFF AND LEIGHTEN 2001
Mark Antliff and Patricia Leighten, *Cubism and Culture*, London, 2001

ANTLIFF AND LEIGHTEN 2008
Mark Antliff and Patricia Leighten (eds.), *A Cubism Reader: Documents and Criticism 1906–1914*, Chicago, 2008

APOLLINAIRE 2002
Guillaume Apollinaire, *The Cubist Painters* [1913] / Peter Read, *Apollinaire and Cubism*, Forest Row, 2002

BALDASSARI 2005
Anne Baldassari (ed.), *The Surrealist Picasso*, Paris, 2005

BARR 1939
Alfred H. Barr, *Picasso: Forty Years of his Art*, New York, 1939

BARR 1946
Alfred H. Barr, *Picasso: Fifty Years of his Art*, New York, 1946 (reprinted 1966)

BAUDELAIRE 1986
Charles Baudelaire, 'A Philosophy of Toys' in *The Painter of Modern Life and Other Essays*, Jonathan Mayne (ed. and trans.), New York, 1986, pp.197–203

BOHN 2002
Willard Bohn, 'From Surrealism to Surrealism' in *The Rise of Surrealism: Cubism, Dada and the Pursuit of the Marvellous*, New York, 2002, pp.121–39

BOIS 1992
Yve-Alain Bois, 'Kahnweiler's Lesson' in *Painting as Model*, London, 1992, pp.65–97

BOIS 1997
Yve-Alain Bois, 'Figure' in *Formless: A User's Guide*, Bois and Rosalind Krauss, New York, 1997, pp.79–86

BRETON 1972
André Breton, 'Manifesto of Surrealism' [1924] in *Manifestoes of Surrealism*, Richard Seaver and Helen R. Lane (trans.), Ann Arbor, Michigan, 1972, pp.3–47

BRETON 1972 A
André Breton, *Surrealism and Painting* [1928], (trans. Simon Watson Taylor), New York, 1972, pp.1–48

BRETON 1996
André Breton, *The Lost Steps* [1924], (trans. Mark Polizotti), Lincoln, Nebraska, 1996

CLÉBERT 1971
Jean-Paul Clébert, *Mythologie d'André Masson*, Geneva, 1971

COWLING 1985
Elizabeth Cowling, '"Proudly we claim him as one of us": Breton, Picasso and the Surrealist Movement', *Art History*, vol.8, no.1, March 1985, pp.82–104

COWLING 1995
Elizabeth Cowling, 'The Fine Art of Cutting. Picasso's *papiers collés* and constructions, 1912–1914', *Apollo*, November 1995, pp.10–18

COX 2009
Neil Cox, 'The Sur-reality Effect in the 1930s' in Elizabeth Cowling *et al.*, *Picasso: Challenging the Past*, Elizabeth Cowling (ed.), London, 2009, pp.87–93

FITZGERALD 1995
Michael Fitzgerald, *Making Modernism: Picasso and the Creation of a Market for Twentieth-Century Art*, Berkeley, 1995

FLORMAN 2000
Lisa Florman, *Myth and Metamorphosis in Picasso's Prints of the 1930s*, London, 2000

GALE 1997
Matthew Gale, *Dada and Surrealism*, London, 1997

GOLDING 1988
John Golding, 'Picasso and Surrealism' in *Pablo Picasso: 1881-1973*, Roland Penrose and John Golding (eds.), Ware, 1988, pp.77–121

GOLDING 1994
John Golding, 'The Blind Mirror: André Breton and Painting' in *Visions of the Modern*, Berkeley, 1994, pp. 246–64

GREEN 1987
Christopher Green, *Cubism and its Enemies*, New Haven and London, 1987

GREEN 2002
Christopher Green, *Picasso: Architecture and Vertigo*, New Haven and London, 2002

KARMEL 2003
Pepe Karmel, *Picasso and the Invention of Cubism*, New Haven and London, 2003

KARMEL 2006
Pepe Karmel, 'Le Laboratoire Central (Dessins Cubistes du Musée Picasso)' in *Picasso Cubiste*, Anne Baldassari (ed.), Paris, 2006

LOMAS 2000
David Lomas, *The Haunted Self: Surrealism, Psychoanalysis, Subjectivity*, New Haven and London, 2000

MCCULLY 1981
Marilyn McCully (ed.), *A Picasso Anthology: Documents, Criticism, Reminiscences*, London, 1981

MILLER 2007
C.F.B. Miller, 'Bataille with Picasso: Crucifixion and Apocalypse', *Papers of Surrealism*, Issue 7, 2007 (www.surrealismcentre.ac.uk/papersofsurrealism/journal7/)

RAYNAL 1922
Maurice Raynal, *Picasso*, Paris, 1922

READ 2000
Peter Read, *Apollinaire et les Mamelles de Tirésias, la revanche d'Éros*, Rennes, 2000

RICHARDSON 1996
John Richardson, with the collaboration of Marilyn McCully, *A Life of Picasso, vol. II, 1907–1917, The Painter of Modern Life*, London, 1996

RICHARDSON 2007
John Richardson, with the collaboration of Marilyn McCully, *A Life of Picasso, vol. III, 1917–1932, The Triumphant Years*, London, 2007

ROSKILL 1985
Mark Roskill, *The Interpretation of Cubism*, Philadelphia, 1985

ROTHSCHILD 1991
Deborah Menaker Rothschild, *Picasso's 'Parade' from Street to Stage*, London, 1991

RUBIN 1989
William Rubin, *Picasso and Braque: Pioneering Cubism*, New York, 1989

STICH 1977
Sidra Stich, *Toward a Modern Mythology: Picasso and Surrealism*, unpublished PhD thesis, University of California, Berkeley, 1977

ZELEVANSKY 1992
Lynn Zelevansky (ed.), *Picasso and Braque: A Symposium*, New York, 1992

NOTES & REFERENCES

1. The latter simile was suggested to me by a member of the Edinburgh audience.

2. Barr 1939, cat. 117, repr. b/w p.85.

3. Raynal 1922, pl.xxv.

4. Antliff and Leighten 2001, pp.180–1, includes two colour reproductions of a *papier collé* of November 1912 – one from 1947 and another very recent one – in order to illustrate the changes in colour of some of the paper elements over time.

5. Zelevansky 1992, p.213.

6. Quoted Roskill 1985, p.23. For a much more complex discussion of the same idea, one that develops a semiological approach, see Bois 1992. For further thoughts on Picasso's ability to conjure up heads out of very little, see Cox 2009.

7. Karmel makes distinctions between different uses of these configurations in different phases in Karmel 2003. He discusses the Edinburgh *Head* in the context of specific formal developments on p.92 and p.163.

8. For an analysis of the use of dressmaking technologies in the period see Cowling 1995.

9. This is Pierre Daix's way of reading the work, in Zelevansky 1992, p.213. He suggests that Picasso applied 'small signs, like the eyes, that make the things spill over into a non-abstract universe'.

10. Richardson 1996, p.279. The work is illustrated though not directly discussed.

11. Karmel 2003, and also, for the argument about constructions, Karmel 2006, especially p.157 and p.162.

12. For a new anthology of these texts, see Antliff and Leighten 2008.

13. In his 'Cubisme et tradition' of August 1911, for example, artist Jean Metzinger noted of his peers that 'because they use the most simple … and most logical forms, they have been made out to be "cubists"': see ibid, p.123.

14. Letter to D.H. Kahnweiler, translated in Rubin 1989, p.416.

15. Golding 1988; Florman 2000; Baldassari 2005.

16. Stich 1977; Bois 1997; Lomas 2000; Green 2002; Miller 2007.

17. Breton 1972 A, pp.6–7.

18. Barr 1946, p.88. This was a revised and expanded version of Barr 1939.

19. Clébert 1971, p.29.

20. For more on the crisis in Surrealism regarding painting, see Gale 1997.

21. Breton 1972 A, pp.6–7.

22. *Playing Cards, Glasses, Bottle of Rum* ('*Vive La France*'), Avignon, 1914–1915, oil and sand on canvas, 54 × 65cm, Private Collection.

23. Breton 1972 A, p.5. *Factory, Horta de Ebro*, 1909, oil on canvas, 53 × 60cm, other more accurate titles of which include *Briqueterie à Tortosa* and *Pressir d'olive à Horta de Saint Joan*, is now in the Hermitage State Museum, St Petersburg. The *Portrait of Daniel-Henry Kahnweiler*, Paris 1910, oil on canvas, 100.6 × 72.8cm, is in the Art Institute of Chicago.

24. The outstanding analysis of the debates concerning Cubism after 1916 or so is Green 1987.

25. Breton 1972 A, p.6. Etienne-Alain Hubert has

suggested that Breton's use of language here and elsewhere in the Picasso section self-consciously refers to phrases in Rimbaud's *Une Saison en Enfer* (*A Season in Hell*). See Hubert, 'Art as event: the Surrealist's reaction to the work of Picasso' in Baldassari 2005, p.210.

26. Some of the best commentary not only on the possible motivations for Breton's judgements, but also for their sources and for the forms of their expression, have been made in Golding 1994. I draw upon his approach here.

27. See Richardson 2007, pp.257-63.

28. Cowling 1985. Richardson 2007 is dismissive of the idea that Picasso was in any way genuinely drawn to the surrealist movement.

29. For a new translation, the original plates and an excellent accompanying essay, see Apollinaire 2002.

30. For detailed information on Apollinaire's play see Read 2000. For *Parade* see Rothschild 1991 and Richardson 1996. Read notes that Picasso himself claimed to have invented the term, suggesting that Apollinaire adopted it, Read 2000, p.140. See also Bohn 2002.

31. Both texts are translated in Breton 1996. Translation modified.

32. See Golding 1994, p.252.

33. Baudelaire 1986.

34. Ibid., p.198.

35. Ibid., p.199.

36. Ibid., pp.202–3.

37. Breton 1972 A, pp.6–7.

38. For another evocation of the work within surrealist writing, see Paul Eluard, 'I speak of what is right' (1935), the relevant passage of which is translated in McCully 1981, p.195.

39. Breton 1972 A, p.4.

40. In Raynal 1922, Picasso's *Head* is followed in the illustrations after only one more cubist work by two realist 'neo-classical' portrait drawings.

41. It is the first in the sequence in the 1945 edition of *Surrealism and Painting* (New York), between pages 24 and 25. In fact, all four of the works Breton discusses were also illustrated Raynal 1922, and so readily available to him in reproduction.

42. *Man with a Clarinet* had been closely studied by Breton in the early 1920s when it was exhibited prior to its sale in the forced liquidation of the property of German dealer and collector Wilhelm Uhde. Uhde had himself bought the painting from Picasso's main dealer, Daniel Henry Kahnweiler, in 1912. The date of the Uhde sale was 30 May 1923 at the Hôtel Drouot. It was then bought by G.F. Reber, who sold it, along with many fine Picassos, to Douglas Cooper in the 1950s. It is now in the Museo Thyssen-Bornemisza, Madrid.

43. This account is based on Fitzgerald 1995, pp.52–6.

44. Letter from Breton to Roland Penrose, 6 July 1936, SNGMA, Roland Penrose Archive A35/1/1/ RPA703/7: 'Merci encore d'avoir songé à acquérir ce papier collé de Picasso. Je sais que votre désir de m'obliger vous a dicté cette offre charmante. Mais je tiens – follement – à garder ce petit tableau que j'ai poursuivi pendant des années avant de pouvoir le contempler à loisir. C'est aussi tout ce qui me reste de Picasso et je crains, ne l'ayant plus, de me sentir plus pauvre encore. Je sais que vous êtes fait pour comprendre admirablement [l]a sentiment.'

45. Letter from Breton to Penrose, 20 February 1937, SNGMA, Roland Penrose Archive A35/1/1/ RPA703/9: '...J'espère que ma situation va prendre une nouvelle forme et que je vais cesser

d'être à charge à mes amis. / On m'a assuré que le Picasso vous parviendrait demain lundi. Puisse-t-il vous être longtemps très émouvant, très tendre et très favorables comme il m'a été durant près de quinze ans.'

46. Of a similar, slightly later work, *Man with a Guitar*, now in the Philadelphia Museum of Art and which was included in the first exhibition of surrealist painting at the Galerie Pierre, Paris in 1925, Breton and Desnos wrote of the figure emerging 'in his immensity from the fog to the groaning of the river's embankment'; Richardson 2007, p.301.